Joan,

To wish you a
HAPPY BIRTHDAY with
Love from Sheena,
Bernlla, Willerby & Wattie

Jan 1991.

DOGS DOGS DOGS

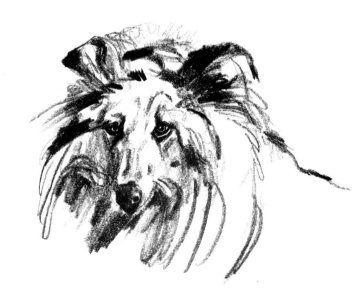

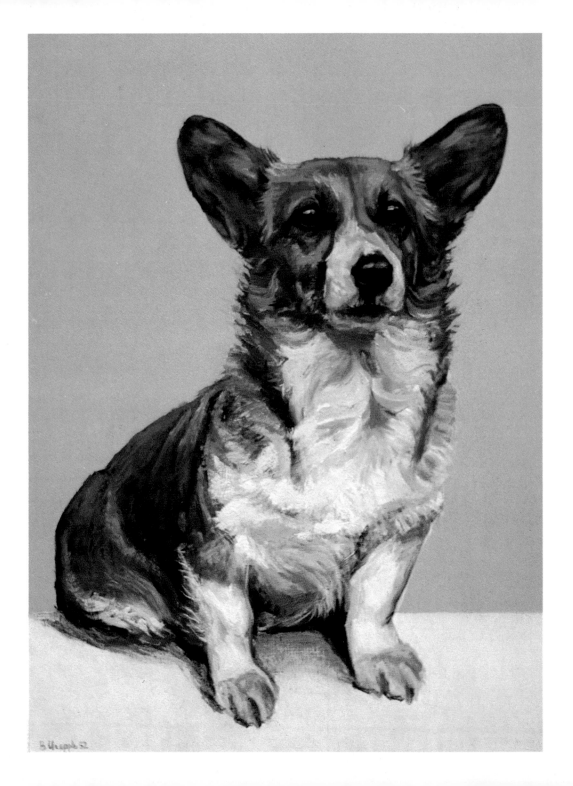

DOGS DOGS DOGS

The best of Beryl Chapple's paintings

Foreword by
Barbara Woodhouse

Thames and Hudson

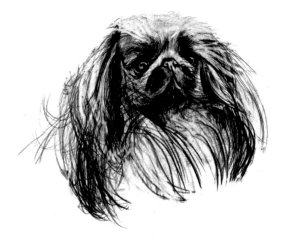

Half-title page Abba, the Rough Collie

Frontispiece Vicky – Chygwyn Vixen – was bred in Cornwall and comes from a long line of Chygwyn Corgis. On a number of occasions she has won prizes at Open Shows, including Best of Breed. Vicky is an affectionate dog and – like most Corgis – highly intelligent.
 Smallest of the Working Group, the Pembroke has been used for hundreds of years as a cattle herder in the hills of Wales. This low-set, sturdy little dog is a special favourite of the British Royal Family and the breed has attained popularity throughout the world.

This page Tuchoos Sobranie, the Pekingese

Phototypeset by Tradespools Ltd, Frome, Somerset
Printed and bound in Spain

Contents

Foreword

When you see Beryl Chapple's paintings you want to go and stroke the dogs. They are so lifelike that the sitters for these portraits will remain not only in their owners' hearts but in their homes for ever. What more can you ask from a portrait or a book?

I hope this collection will give its readers enormous pleasure.

Barbara Woodhouse

Introduction *Suki*

One hot sunny day in 1966, a small scruffy mongrel peered out from behind wire netting at the local kennels in Malta. Many other pairs of dark eyes were also looking up at me, but Suki had to be mine — perhaps because she was the ugliest of them all! She had a white shaggy coat, short docked tail and one black patch covering her left eye, with just a few grey mottles on her alert pricked ears. Her legs were long and gangling, with the little tail that never ceased to wag. Most of all, she showed affection from the start, licking my fingers continuously through the wire mesh which separated her from me.

Strangely, the new van parked outside the kennels had written on the side: 'Donated from the people of Haslemere, Surrey'. This was my parents' home town in England, where I had spent much of my childhood before attending Art School in the nearby market town of Farnham.

Suki lived eight happy years in Malta and, after my return to England, ten perfect years in Cornwall, where she was adopted by my parents. When she was in her seventeenth year she stayed with us for a short holiday in Truro. She had already reached a great age and I wanted very much to find a way of immortalizing her. It was then that I decided to paint a portrait. My husband, Michael, suggested that I portray her life-size; and that was really the beginning of my subsequent long line of portrait commissions.

To our sorrow Suki died on 22 January 1982. She was laid to rest in the garden of my parents' home at Sennen near Land's End, where she had spent so many joyful hours.

This book is dedicated to Suki, without whom the inspiration for these paintings might never have been born.

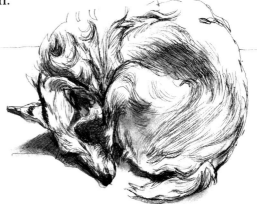

Foxy

Moonswift Moonpearl

Moonswift Moonpearl, pet-named Foxy, was born on 15 December 1972 with an impeccable pedigree. She was neglected for the first four years of her life, but her new owners in Cornwall began to give her all the care, love and attention she deserved. Soon she became a consistent winner at shows.

Foxy is now a veteran, but still carries herself with the dignity and supreme aloofness which is so typical of her breed. She is a true aristocrat – a quality which I have tried to capture in this painting. Her every position is graced with beauty: a natural flowing rhythm of shape and form. Ever watchful, she seemed instantly at home posing on a richly decorated Eastern rug.

AFGHAN HOUND The Afghan Hound probably originated in the Middle East, but subsequently became established in the bleak and rugged countryside of northern Afghanistan. The dog developed as an animal of incredible speed and great stamina, with a long shaggy coat to withstand the extreme cold on the hills in which it lived.

The Afghan was introduced to Western Europe by returning British officers who had served in India. A Breed Club was formed in 1925 and in that year Afghans were recognized in the USA. Today, the Scandinavian countries, Australia, Canada and many other places have a vigorous body of Afghan breeders and enthusiasts.

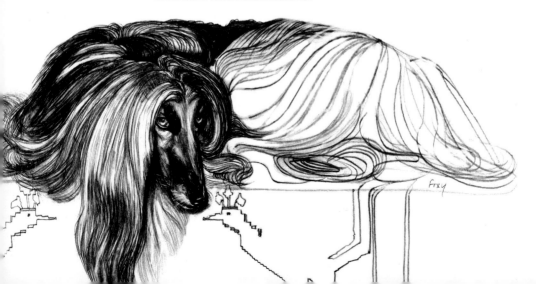

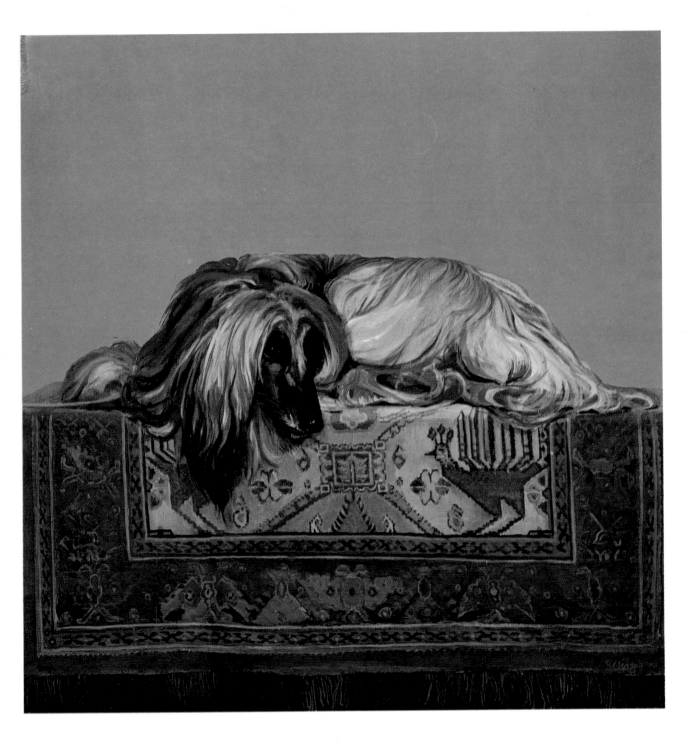

Snoopy

This lovely dog is known by the name of Snoopy. He posed patiently for his portrait at the grand old age of thirteen. A few months ago Snoopy suffered a severe stroke and for a while his life was in danger; but he has now recovered completely and despite his advancing years is again appearing in veteran events at shows. When younger he won on numerous occasions in Obedience Classes and in the Breed Ring. Snoopy loves going in for fancy-dress competitions and in one of his recent star performances he was dressed as a pirate for a summer show in Cornwall.

COCKER SPANIEL The Cocker Spaniel is directly descended from the first spaniels, so called because of their Spanish origin. Spaniels are the largest family in the canine race and date back as a group to the 14th century. The Cocker itself, known in many countries as the English Cocker Spaniel, is one of the most popular breeds in the world. The name 'Cocker' is derived from its uncanny skill at hunting woodcocks and its ability to 'cock' or drive game from cover. Used extensively for hunting, these dogs love difficult terrain and are very fast. Today they are predominantly family pets: easy to train, and intelligent, lively and affectionate companions.

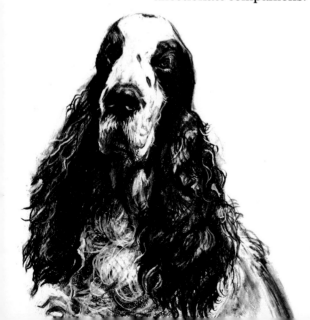

Jodie's parents were Delvista Shirralee and Delvista Rory. He was born on 18 August 1978 and, whilst still only a small puppy, greeted his new owner with a surprise gift – a slipper. Thus began a most rewarding relationship: from that day onwards Jodie always welcomed his mistress with a present.

His favourite pastimes were walks in the woods and by the river, playing with children, riding in the car and digging holes in the garden. On lazy days he was to be found sleeping in the adjoining field with his friend the bull.

Jodie enjoyed being shown and won many prizes, his last being the much-coveted Best in Show award; but a mere two weeks after that success his terminal illness was discovered and, to avoid further suffering, he was put gently to sleep in his owner's arms on 10 July 1981.

THE GOLDEN RETRIEVER The origins of the Golden Retriever are rather obscure, but it is known that these dogs were developed in England after the Crimean War in the 1850s as a result of crossbreeding.

The Golden Retriever began to establish itself at the beginning of this century and as a show dog it has a reputation for being quiet, well behaved and obedient.

Since the end of World War II it has become increasingly popular as a pet and is very good with children. A friendly and adaptable breed, it is capable of being an excellent gun dog, a dedicated guide dog for the blind and a reliable companion.

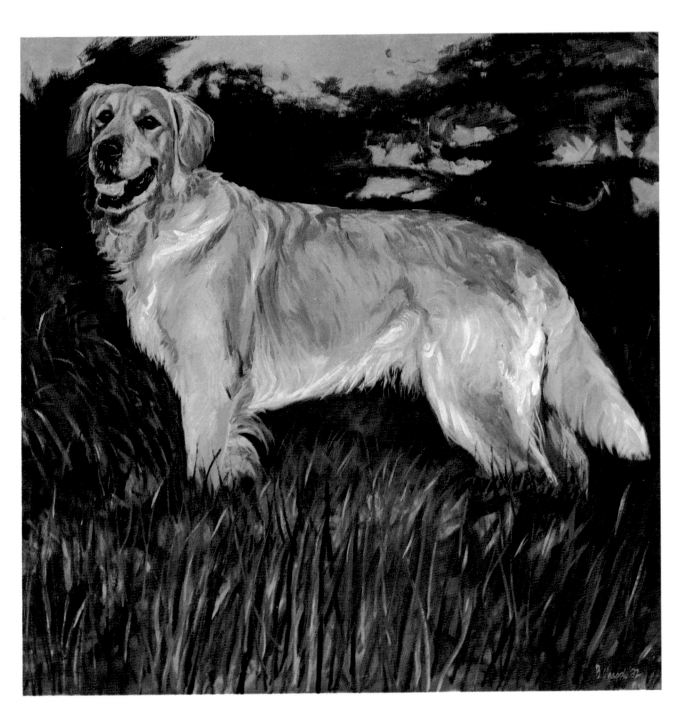

Susie

Susie the St Bernard, a breed associated with rescue, was herself rescued when eighteen months of age. Although you could then count almost every bone in her body, she was soon to develop into the impressive character she is today. Susie is reluctant to accept any sort of dog into the home, but has warmly welcomed three of her own kind, Hercules, Paddington Bear and Rosa. They all live together as one happy family.

Susie knows that there is an ever-plentiful supply of goodies just round the corner in her owner's grocery shop and I was able to command her unceasing attention by placing a sweet biscuit on the top corner of my sketchbook!

ST BERNARD World famous for its mountain rescue work, this massive breed was first developed by monks at the Hospice of the Great St Bernard, high in the Swiss Alps, between 1600 and 1670. St Bernards are able to work at sub-zero temperatures and have an amazing record of success in mountain rescues. They can locate a body buried by as much as ten feet of snow and scent a human being against the wind up to two miles away, though today they are more commonly found in the show ring or within the comfort of a family home.

unkey
green
brown
black.

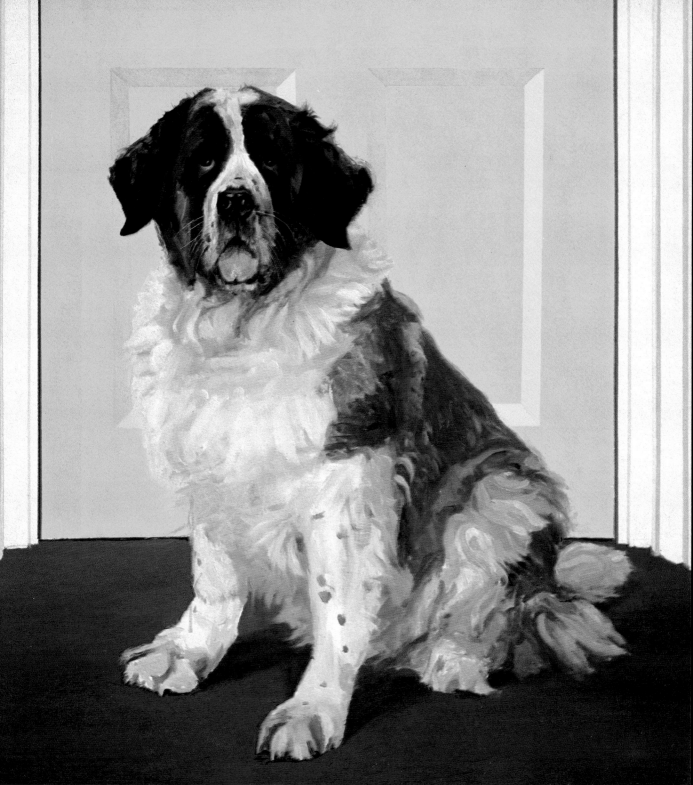

Jenny

This cold-nosed twinkle-eyed little dog — once known as Chips: little sausage — was uncared for and unloved in her early years; but at the age of three, all that changed to happiness, with a new home and loving mistress who re-christened her Genevieve. Jenny — as she was called for short — always greeted her owner's homecomings with great excitement, a reward to them both. Yet one of those ecstatic welcomes was her undoing. Poor Jenny leapt on to her owner's lap, which was far too high for such short legs. So painful was the injury to her spine that only a last visit to the vet could relieve her suffering.

DACHSHUND (*Miniature Smooth*) The Miniature Dachshund is very self assured, with an affectionate and intelligent temperament. This sturdy little sporting dog is always ready to hunt anything that moves. A true hound in origin, the Miniature Smooth was bred in Germany for the specific purpose of going to ground after small game such as rabbits. It is persistent and determined in the chase and, despite its small size, capable of great exertion.

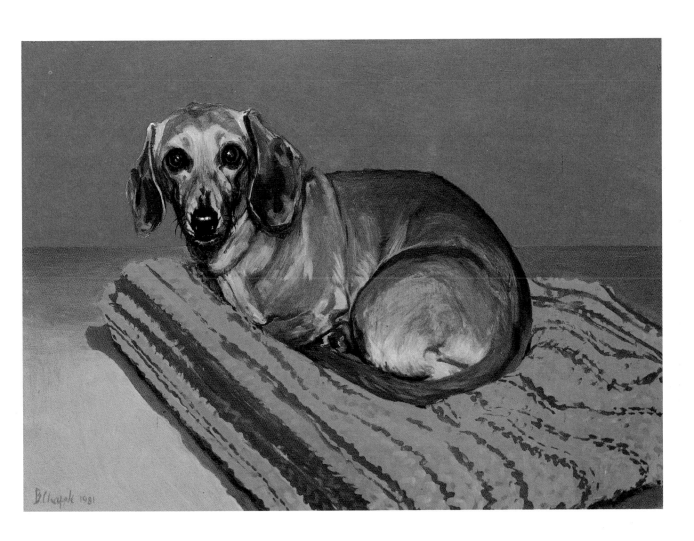

Grizelda

Grizelda, the weakling in a litter of eleven puppies, was fostered out by her breeder to a Pug for the first few weeks of her life: a strange beginning for a wonderful dog that was to become a Kennel Club Champion. Her owner's proudest moment came when she won Best of Breed at Crufts for the second time and her son, Quethiock Warrior, won Best Novice dog.

Although she made many public appearances and featured in a film, Grizelda was first and foremost, 'just one of the family'.

IRISH WOLFHOUND Of all dogs, the largest and perhaps the most impressive is the Irish Wolfhound. This ancient breed was once used by Irish Kings for hunting wolves and the Irish Elk. When these animals became extinct, the Wolfhound almost disappeared, but it was revived by the efforts of Captain Graham of Dursley, who founded the Irish Wolfhound Club in 1885. In 1897, the English Kennel Club admitted the Irish Wolfhound to its register and the breed now appears at shows in almost every Western country.

Although still very much the hunting dog built for power and speed, the Wolfhound has a quiet, gentle and friendly temperament.

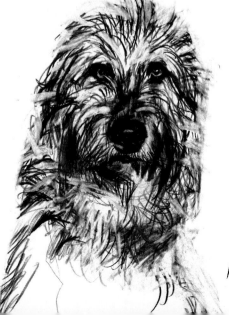

Patrick

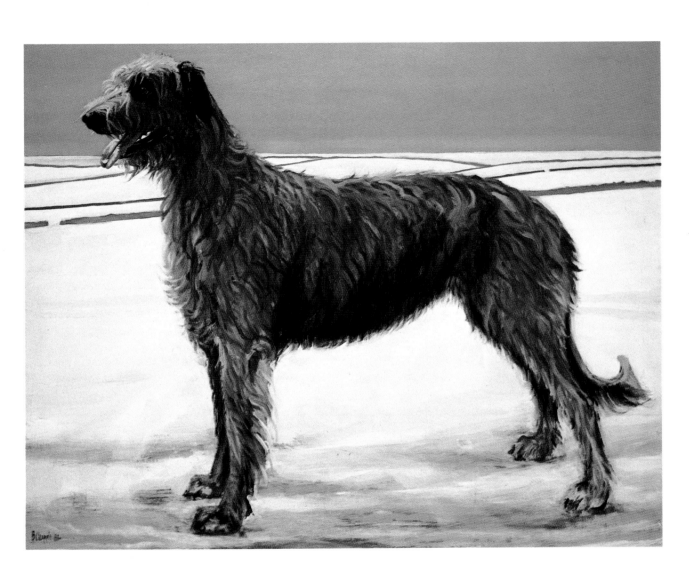

Oscar

I was very much aware of Oscar's presence long before we had been formally introduced. The sheer visual impact and size of this magnificent dense black creature impressed me profoundly.

Oscar's show career was cut short by a skin disorder, but he is now in the best of health and living happily in the country, where his companions are goats, rabbits and various cats. He has remained a fun-loving, affectionate, mischievous character that everyone grows to love and he will long be remembered for the loyalty and pleasure that he has given to his human friends.

STANDARD POODLE The Standard Poodle is the largest and probably the oldest member of the Poodle family. It is almost certain that he was originally a gundog. He has been used for centuries on the Continent as a water retriever. To enable him to swim more easily, the hindquarters were clipped, leaving those areas covering the wrist, ribcage and hocks as protection against cold and rheumatism. Today, this very old tradition – known as the Lion clip – is used mainly for showing.

The Poodle is remarkably intelligent and for generations was extensively used as a performer in the French circus. In recent years his status has risen considerably and he has become one of the finest show dogs.

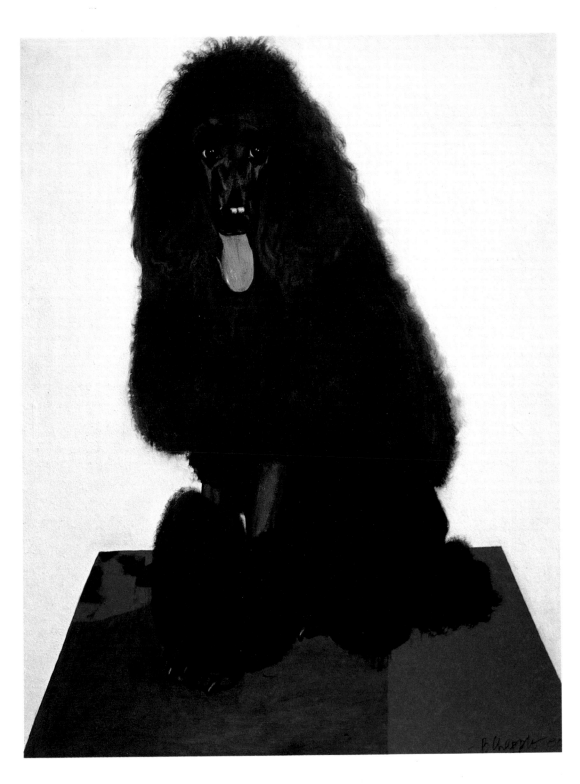

Sally and Duchess

In retrospect, it was perhaps foolish of me to suggest that these bulldogs should be tied together whilst standing in the garden on a hot summer afternoon. As I began making studies for my first double portrait, their panting suddenly gave way to growls, snarls and gnashing of teeth! After a very necessary and hazardous separation, they behaved perfectly as I drew them one at a time in the shade.

Sally, on the right of the painting, last year became the proud mother of nine puppies. Duchess was so missed by her original owner that she eventually went 'home'. Since then she has had three puppies, one of whom is now settled happily with Sally's family to make up for losing Duchess herself.

BULLDOG The origin of the Bulldog has been traced back in Britain to the reign of Elizabeth I in the sixteenth century. It was then referred to as the 'Bull dogge' and used in the ancient sport of bull baiting, a popular and cruel practice that took place regularly in Britain until it was made illegal in 1884. The early fighting dogs bred for this purpose were of Mastiff-type and the Bulldog was produced by continuous breeding for shorter legs. After the abolition of bull baiting, bulldogs were in danger of extinction; but thanks to the dedication of a few specialist breeders their temperament improved. The bulldog of today has all the affectionate and endearing qualities that we can see in Harvey.

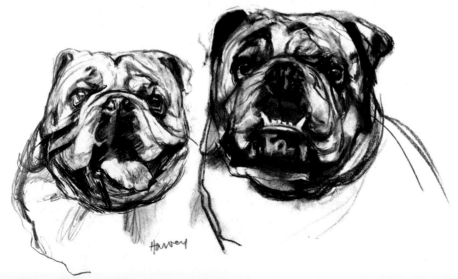

Harvey

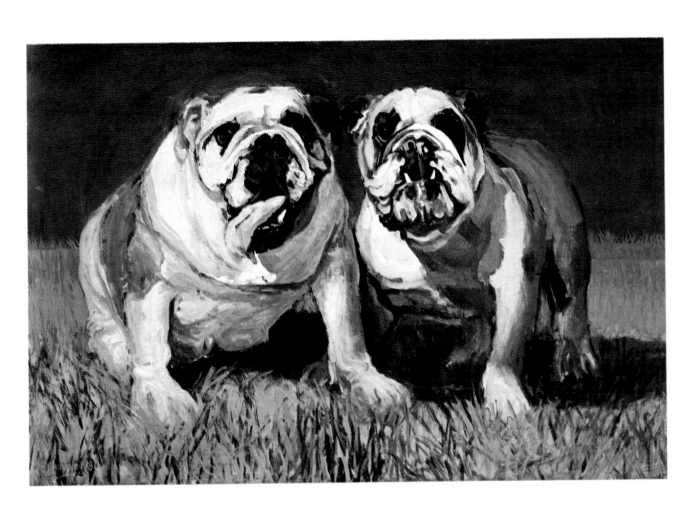

Denim

Masnou Isidonna of Tredark

Denim's owner unhesitatingly replied, 'a Great Dane', when invited to choose a wedding present by her husband. And since she is half American, perhaps it was providential that her choice of dog came from a litter born on the 4th of July. One puppy stood out, the cheekiest and most mischievous of eleven. As she was blue, and blue jeans were being worn that day, Denim just had to be her name.

On the farm, her cheeky characteristics prevailed, but she developed into a beautiful show dog. Later, when a marriage was arranged, a quick courtship did not suit her. Twelve hundred miles, and a year and a half later, Denim made her own choice, becoming the mother of nine handsome puppies.

In this painting, and to the world, she is Masnou Isidonna of Tredark; but to her owners she's just Denim, the most wonderful dog of all.

THE GREAT DANE The Great Dane is a majestic and elegant dog whose true origin is not known. It probably descended from the large Mastiff-type dogs of ancient times that were used in hunting and war. From the latter part of the nineteenth century, Germany played a major role in developing the Dane. Today, the Great Dane is immensely strong and active, with a gentle, charming temperament.

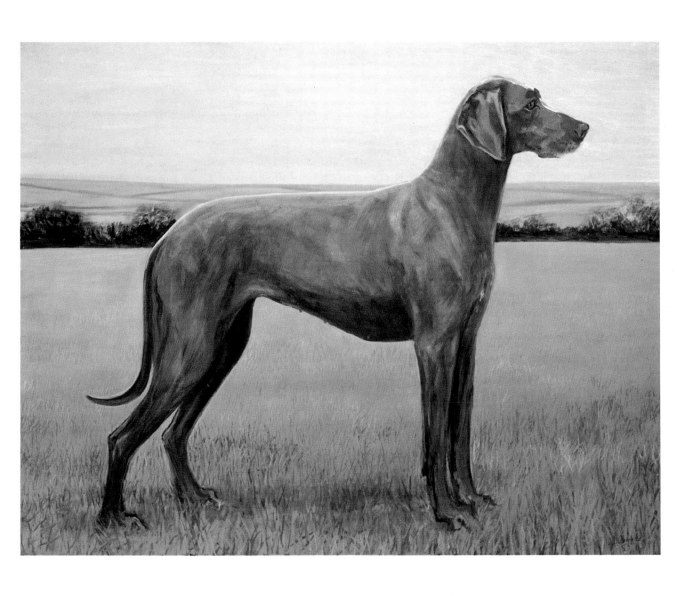

This portrait was commissioned to celebrate Vir's tenth birthday. He was born in France on 20 November 1972 and was just twenty-four hours old when first seen by his present owner. Eight weeks later, she collected Vir from the breeder and took him back to England, regularly making the hundred-mile journey each week to visit him and to start his essential training during quarantine. Within a few days of going home, Vir entered his first show and immediately qualified for Crufts, the prelude to many exciting wins. The proudest day of all was to come at Windsor in 1976 when he became a Champion.

BRIARD The Briard, or Chien Berger de Brie, is probably descended from sheepdogs which accompanied the barbarian invaders of Europe after the fall of the Roman Empire. This breed is found in most parts of France, but takes its name from the Province of Brie. Briards are fearless fighters and were used centuries ago by French farmers to fend off wolves and robbers. They led very busy lives on active service with the French army in World War I, but today they are increasingly popular as a show dog, family pet and companion.

Zeno of Baldslow

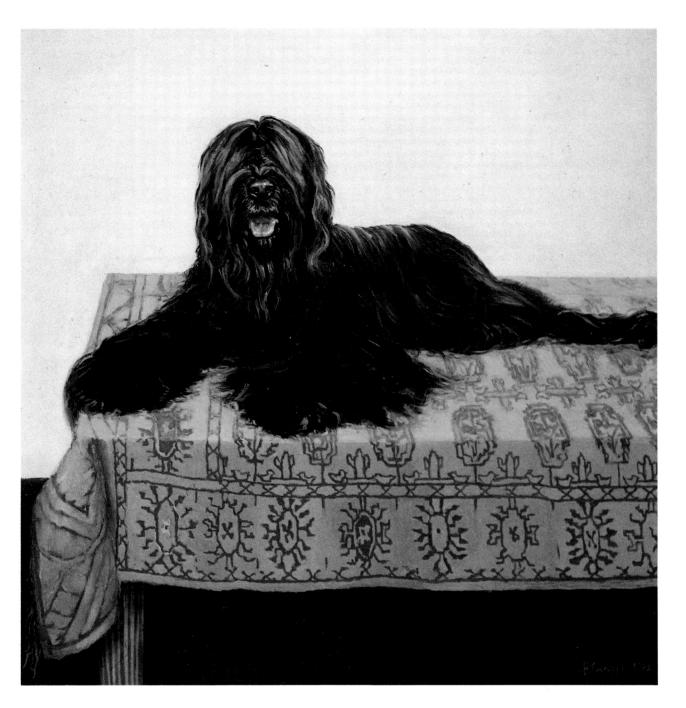

Lisa

Lisa, who lives in Cornwall, was born in September 1976. Like most Retrievers, she loves water. Each day she goes down to the sea to swim, but her sublime happiness is wallowing 'hippo' style in the muckiest gorge she can find. This happens frequently! Back home, she enjoys lying in the garden surrounded by birds, who feel safe in the knowledge that she is a dedicated cat chaser. Despite this, her closest friends are two stray cats who have somehow won her favour and affection, though she will not tolerate any other cat in the area.

Lisa adores people and will do anything to become the centre of attention. Those who dare to ignore her find her nose under their cup and saucer or glass as she tips it over. Once she finds a sympathetic listener, she will hold a lengthy conversation: noises which truly have to be heard to be believed.

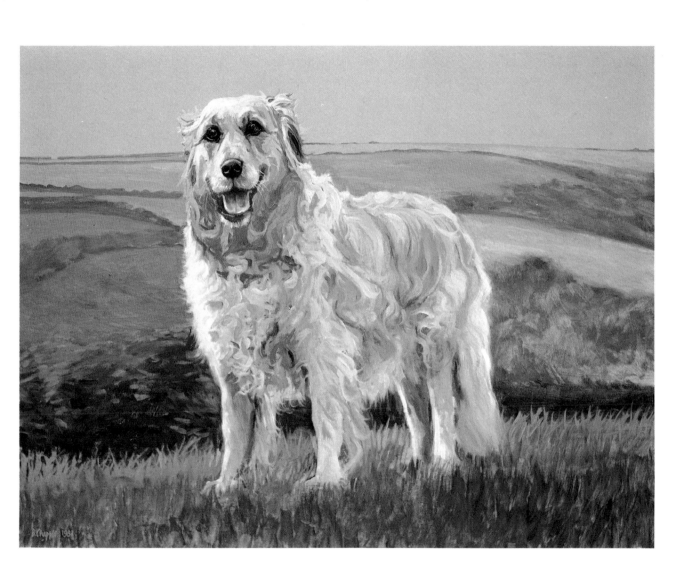

Coaster

Coaster was purchased in December 1981 as a mascot for a television company in the south of England – TVS. After much debate, a liver and white Springer Spaniel was decided upon, for she would reflect the company colours: cream and brown. Coaster was to take her name from the TVS current affairs programme 'Coast to Coast'.

Since those early days she has appeared many times on television, quite often staying for the whole length of the programme under the desk at the feet of her owner. She is also having gundog training and was seen on television picking up on her first pheasant shoot.

ENGLISH SPRINGER SPANIEL There is little doubt that this breed is the oldest of all English gundogs. During the Middle Ages these spaniels were bred for finding and springing game for the net, falcon and greyhound; hence the name 'Springer'. Nowadays the dogs are used to flush and retrieve small game for the gun. They are tireless workers in the field, excellent retrievers and very good in water. The English Springer is one of the larger spaniels, a strong robust dog built for endurance and activity. When kept as a pet it requires a great deal of exercise and training.

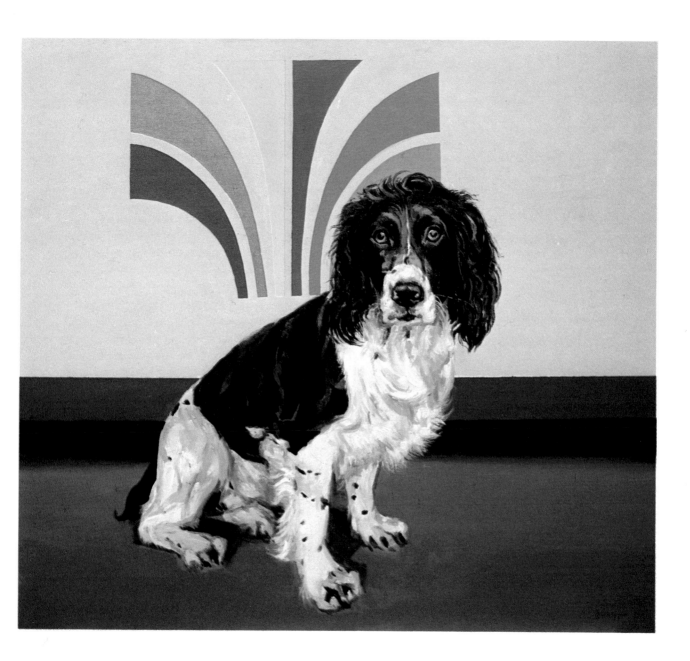

Tinkerbelle

In the late summer of 1982, *She* magazine announced a competition: 'Win a portrait of your pooch'. The prize was to be a life-size painting by me of the winner's dog. Months later, below the ramparts of the old castle at Scarborough in Yorkshire, I was introduced to the mystery winner and her Old English Sheepdog called Tinkerbelle.

Tinkerbelle is an extravert of great character. She is a strong, country-loving dog who demands miles of exercise, enormous fuss and special treats in return for guardianship and adoration. She loves beaches, long wet grass and stable yards. In the words of her owner, 'Tinkerbelle is an admired and respected citizen when she's "Belle"; but sauntering home thoroughly filthy again she's "Tinker"!'

THE OLD ENGLISH SHEEPDOG The Old English Sheepdog is the largest and probably most well known of all British pastoral dogs. At one time, these dogs were commonly known as bobtails, perhaps due to the tradition of docking their tails, a practice which identified them as working dogs and provided an exemption from tax. The Old English Sheepdog is now an established favourite among dog lovers everywhere.

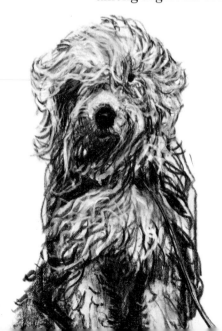

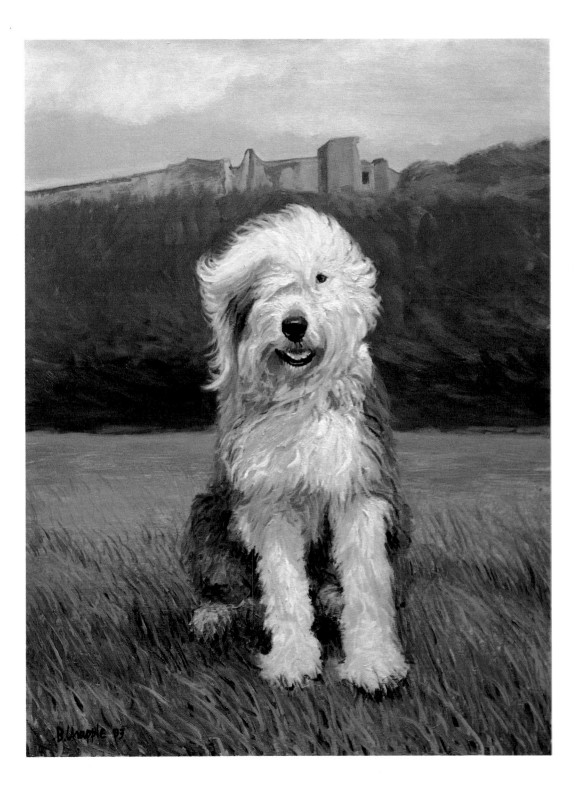

B. Chapple 93

Ben

A dog's dream came true for Ben at the age of six months: he entered a world of meat and marrow bones by becoming a butcher's dog. For the next three years his main passion in life was chewing; but to his owner's dismay Ben did not restrict his activities to bones. Instead, he chewed other things for his own very special reasons. Just after moving into his new home he became jealous of the television: he didn't like it at all! One day his owners returned to find that he had completely demolished the set; he had chewed the casing and rootled out the works, which were all over the floor. Another time he managed to gnaw right through the dining-room wall. Still, that's all in the past, for Ben is now mature and chews only his daily ration of bones.

I chose his favourite place for this painting — at the top of the stairs, where he can see everything that's going on. Although bones are out of bounds up there, I couldn't resist putting one in the picture. Ben also loves sitting outside the shop, welcoming all the customers and their dogs; but after the shop's closed at night he takes on the role of protector and guard, refusing any dog entry to the premises.

LABRADOR RETRIEVER The Labrador, originally from that famous fishing area of Newfoundland, is perhaps best known as a gundog, but it is very versatile and, in addition to its work in the field, is popular as a show dog and pet. During World War II these dogs proved a valuable asset in mine detection, locating (by scent) mines that were sometimes buried at considerable depths. Labrador Retrievers are currently used with the police in criminal work for sniffing out drugs and are excellent in their faithful service as guide dogs for the blind.

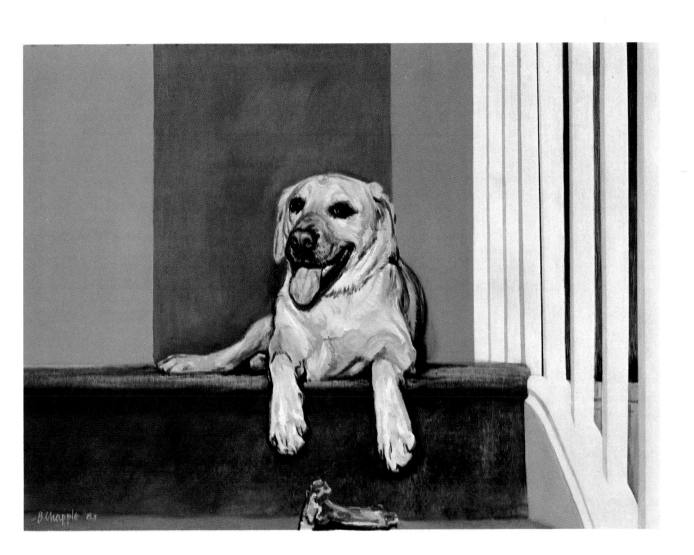

Binny

Trevosa Black Bee

Binny sat perfectly still for an hour and a half while I made the first studies for her portrait: she loved all the attention and praise. On the rare occasions when she is scolded, she closes her eyes tightly as if to say, 'I can't see you, so you can't see me!' Binny is a gentle, beautiful dog, who has achieved consistent success at Open Shows.

SHETLAND SHEEPDOG The graceful Shetland Sheepdog, as its name implies, comes from the Shetland Isles off the north coast of Scotland. The breed was at one time known as the 'Miniature Collie' and the islanders used these little dogs for centuries as sheep herders. During those early days they tended to be unpredictable in type and it is only since they became recognized as a breed by the Kennel Club in 1914 that dedicated British breeders have succeeded in producing the delightful little Sheltie we know today. The Shetland Sheepdog still retains many of the characteristics of its working ancestors, and in spite of its somewhat delicate appearance is a hardy and sturdy dog.

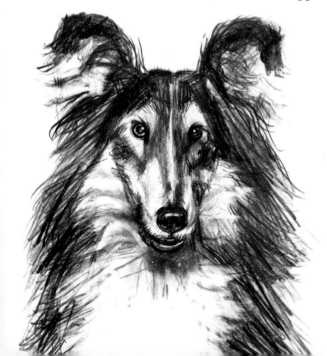

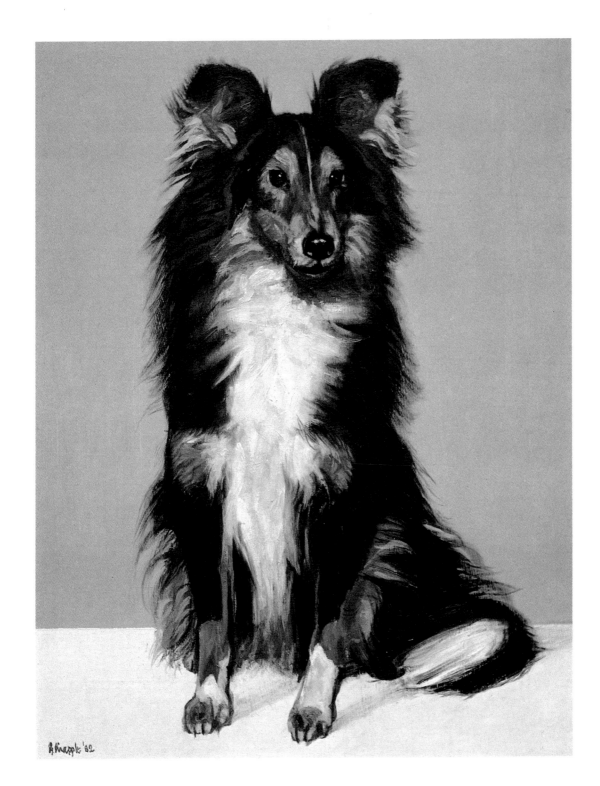

Whatsit

Everyone kept asking 'What is it?' So he was given the name of Whatsit. This dog of bizarre appearance appealed to me immediately. It was my first encounter with a Puli and I found his corded coat particularly fascinating. The coat hung down everywhere, even over his eyes, which prompted me to ask his owner if the cords obscured Whatsit's vision. He assured me that his dog could see perfectly, despite the thick curtain. Then I showed Whatsit my portrait of Patrick, a huge Irish Wolfhound. He barked ferociously, well and truly proving the point!

Whatsit made breed history early in life by winning a Best Puppy in Show award, the first ever Puli in England to do so. He went on to become a top winning show dog and achieved championship status at the age of four.

HUNGARIAN PULI This ancient breed is a rarity in many parts of the world, but is nevertheless probably best known outside its native country. The Puli is the smallest of Hungary's three sheepherding breeds and is a worker rather than a guard. These dogs have a unique form of movement, with a very fast short stepping stride, and often control the sheep by jumping over or even on to their backs.

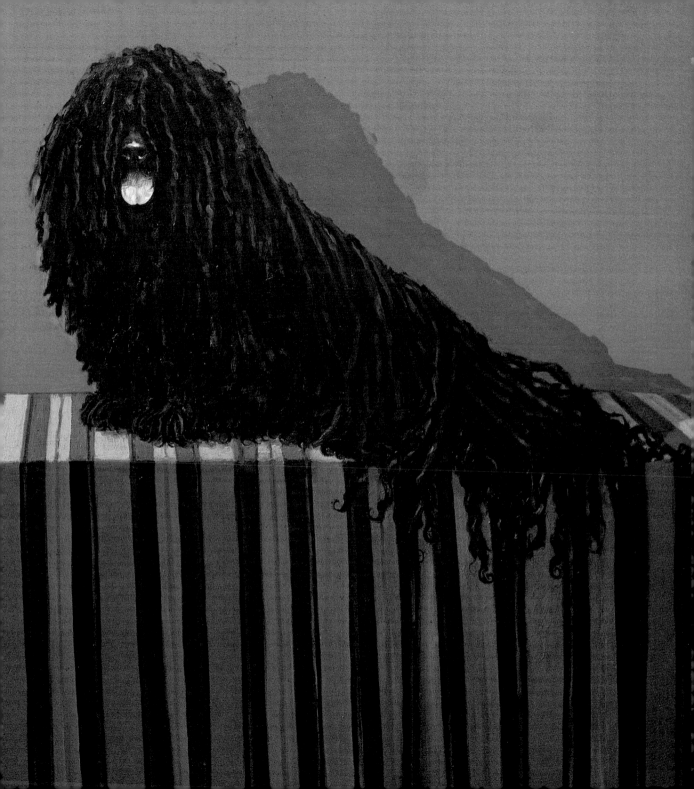

Tillie

Tiny in size but with a big heart is this little Chihuahua, affectionately known as Tillie. She has a very determined nature and rules her home with a 'paw of iron'. She is a good house dog and her bark can be heard for miles around. Tillie loves a saucer of coffee after her meal and walks round the table on her hind legs, stalking with little growls, until it appears. She delights in shopping, travelling inside the coat of her owner with just her head and front paws showing. People stop to admire her – praise which she accepts with haughty disregard.

Although Tillie is somewhat nervous, she soon establishes her authority over other dogs. She has four cousins, all about Retriever size, and loves to play with them; but if things become too rough, she does not hesitate to attack, flying at their throats with teeth bared and snarling until they take to their heels and run!

Still, Tillie is a dainty little lady, full of love and sweetness. She adores a cuddle and brings much joy to the hearts of her owners.

CHIHUAHUA Today the Chihuahua is one of the most popular Toy dogs. It was named after the Mexican state of Chihuahua, in which this diminutive breed first came to the attention of dog lovers. The Chihuahua is believed to be descended from the sacred dog of the Aztec Indians, but there are many conflicting theories and stories about its ancestry. Present-day Chihuahuas are derived from a relatively small number that were imported into the United States between 1850 and the end of the century. These long-lived little dogs are dainty, compact and alert, with the character and intelligence one expects to find in a much larger breed.

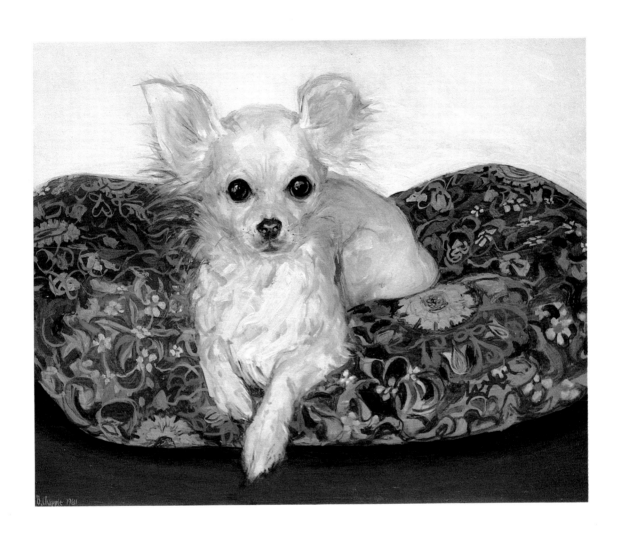

Candy

Candy was born on 8 February 1977. He is one of a very happy kennel family and enjoys life to the full among his fellow Cavaliers. Candy is not mischievous but curious. He loves investigating and will squeeze through the smallest of holes just to see what's there. It did not take him long to work out how to open the kennel gate by putting his paw through the gap and lifting the latch on the other side! Candy is an excellent father and many of his sons and daughters are currently winning top honours in the show ring.

CAVALIER KING CHARLES SPANIEL Temperamentally, Cavalier King Charles Spaniels are gentle and affectionate, with a great love of people. They are direct descendants of the Toy Spaniels which existed in Europe centuries ago. Many were owned by royal and noble families on the Continent and became great favourites of the English court, especially in the reign of Charles II. Later, when people began to take an interest in dog shows, it became fashionable to breed a much shorter-nosed variety. In 1926 an American visitor to England, Mr Roswell Eldridge, was so concerned at the disappearance of these dogs in their original form that he decided to offer prizes of £25 at the Crufts Show for the best dog and bitch of the original type. As a result of his initiative, pioneers of the breed had considerable success in fashioning and developing a similar kind of dog. A Cavalier King Charles Breed Club was registered in 1929 and the word 'Cavalier' added to the breed name.

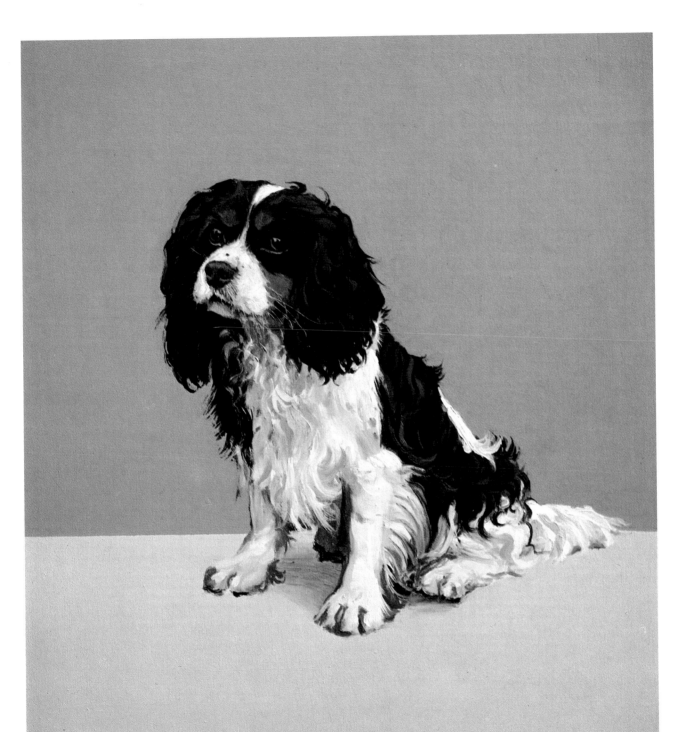

B. Chapple 1981

Boots

Boots was so excited at the prospect of having his portrait painted that, as soon as he arrived to be drawn, he chased at speed round the garden, running several times in and out of the house and throughout the rooms upstairs and downstairs. When he realized exactly what was expected of him, he posed beautifully with the self-confidence and dignity of one whose welcome was assured – surprisingly so, for Boots had survived a cruel upbringing, locked up in a small room for the first fourteen months of his life. On being rescued and at last being given his freedom, he slowly learned to adjust to a normal happy life with his new owner. Only too aware of his sorry background, she resolved that the door would never be closed to him: that he could choose to go or stay. Boots has stayed until this day.

THE MONGREL Wherever man settles, his best friend the Mongrel can be found. Just as nature intended, the offspring of countless breeds, he is certainly the most numerous and probably the most popular dog in the canine race. He is an appealing character and comes in all sorts of sizes, shapes and colours. Often remarkably intelligent, he has become a loving member of the family in millions of homes throughout the world.

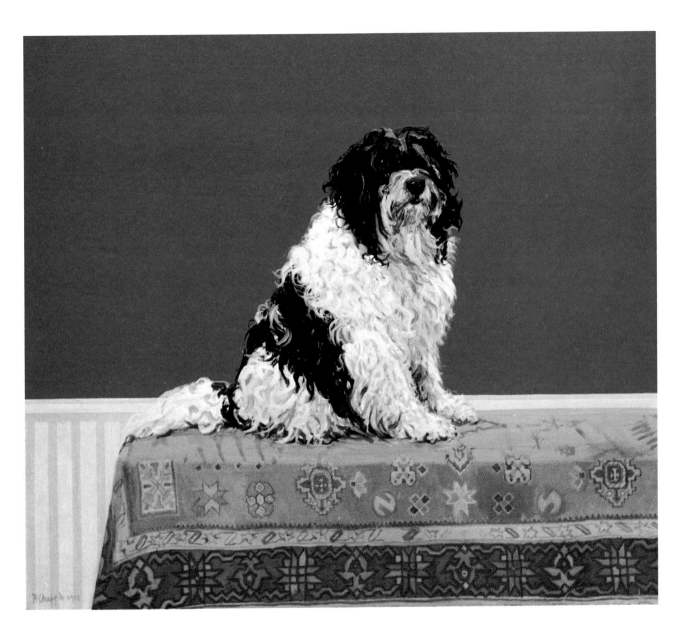

Tara

Quevains Solataire

Tara was born on 20 March 1978; since she was the only puppy in the litter, she was given the name Solataire. Now four, she has retired from the show ring to be a happy, contented mother.

She was unbeaten top Pomeranian in Cornwall and the only Pom in the county to have won a Challenge Certificate.

Despite her small size, she stands up bravely for herself and, however big her opponents are, will invariably 'see them off'!

POMERANIAN This attractive little dog has evolved from the German Spitz breeds which were exported into Britain about a hundred years ago. It is closely related to the Samoyed, the Elkhound, the Keeshond and most probably the Chow.

Originally the Pomeranian was a much larger dog, but selective breeding has reduced its size and it is now known as one of the Toy dogs.

Queen Victoria took an interest in the breed on a visit to Florence in 1888 and in 1891 she showed six Pomeranians at the Crufts Show. Their popularity soared and the same year a Breed Club was formed. When the Queen died at Osborne, Isle of Wight, in January 1901 her favourite black Pom lay on the bed at her feet.

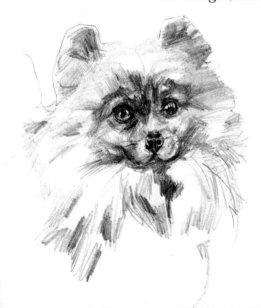

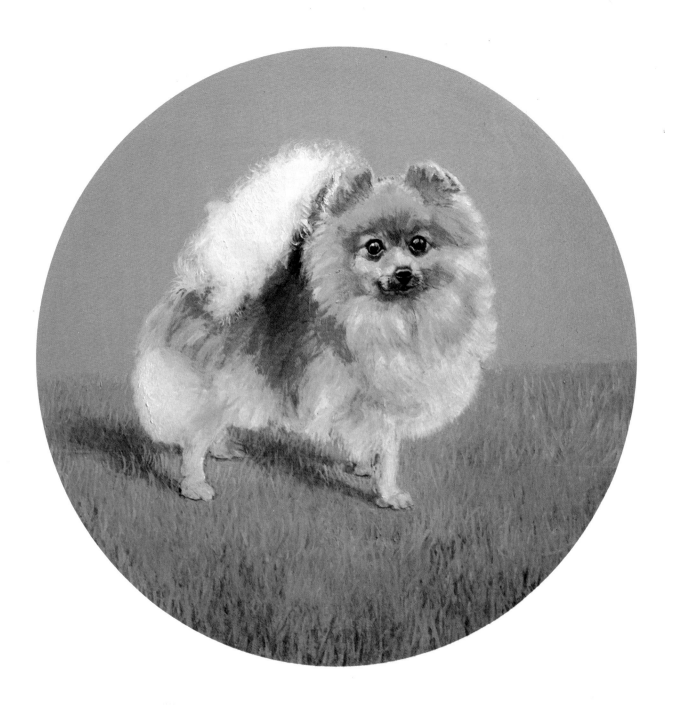

Midget and Fidget

This double portrait shows a happy and inseparable mother and daughter: Midget on the left hand side of the painting, posing in cosy togetherness with her daughter Fidget. Midget's and Fidget's 'kingdom' was a special extra-comfortable armchair, with sawn-off legs, on which they would regularly curl up together; and woe betide either of the cats if they tried to use it!

Last year poor Midget died and from that day Fidget pined. She refused to eat and abandoned the 'kingdom' which had meant so much. Now Fidget is at last taking an active interest in everything again, even if she needs more love and cuddles than ever before.

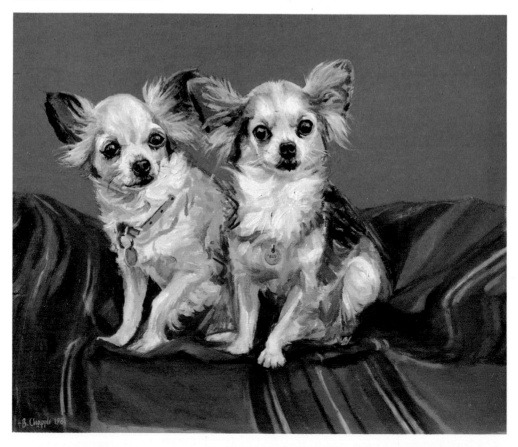

The Viking
James Bond
Paris

Champion Brackenacre The Viking
Champion Brackenacre James Bond
Champion Brackenacre Fino de Paris

In this painting I have portrayed a famous line of living champions: grandfather, father and son, set against the unspoilt landscape of Dartmoor. Standing on the left of the picture is a proud veteran of the show ring, Paris. In his younger days he achieved outstanding success by winning thirteen Kennel Club Challenge Certificates, Best of Breed in 1973 and 1974 at Crufts and also in 1974 the coveted title: Basset Hound of the Year. James Bond sits in the middle. He is a similar type to his father, with the sweetest temperament imaginable. He has sired champions and in 1982 won the Basset Hound Club Trophy: Stallion Hound of the Year. On the far right stands The Viking, a great character, possessing many qualities of his father and grandfather. Aged two, he already has a total of twenty-one Challenge Certificates. In 1982 he was awarded the title Basset Hound of the Year and listed as one of the top twenty dogs of all breeds in the British Isles.

BASSET HOUND Scent hounds of mixed type were being bred for hunting as early as the sixth century, but it was not until 1585 that first mention of the word *Basset* appeared in the book *Venerie de Jacques du Fouilloux* . The author devotes several pages to Bassets and their work as badger dogs. In the nineteenth century, a pure-bred Basset strain was developed by selective breeding. In Britain immediate interest was aroused in the breed after it was imported from France in 1866, and the Basset Hound Club was formed in 1883. Since those early days, the Basset has gone from strength to strength and it is now one of the most popular breeds in the Hound Group. Today, there are few climates, from temperate to tropical, where this magnificent breed does not flourish.

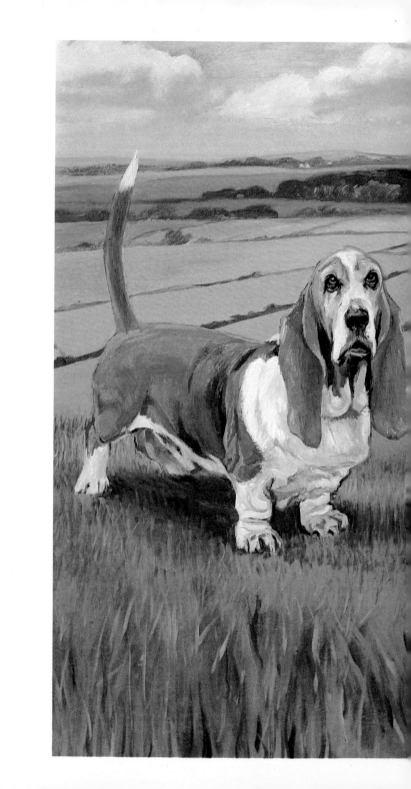

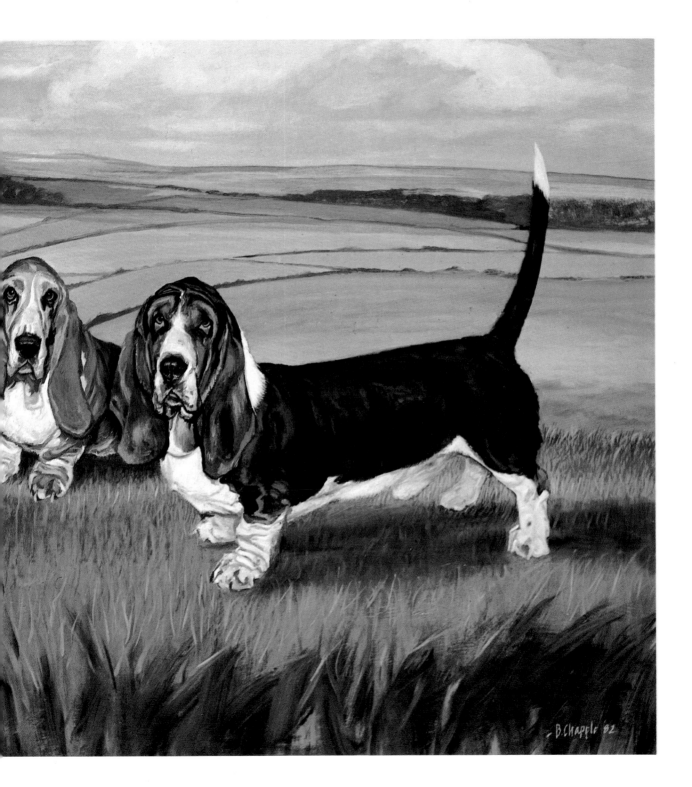

B.Chapple 82

Hayworth (after Rita), also answering to Nip, was born in Wilmslow, Cheshire, probably in 1978. She was owned by a taxi driver and often accompanied him at work in his cab. As a result, she enjoys travelling in cars, either standing on the front seat with paws on the dashboard and staring through the windscreen, or curled up asleep on the floor by the heater. She is never car sick. After the taxi driver emigrated, Hayworth came to Truro in Cornwall with her new owner, and is a good family dog.

She likes hunting, sleeping and meeting people in pubs. She hates cats and flies into an insane rage at all sightings. Could she have been hurt by one as a puppy?

JACK RUSSELL TERRIER The Jack Russell is today one of the most commonly seen Terriers in countries as far apart as the USA, Australia, Sweden and South Africa. It was developed originally in the early part of the nineteenth century by a Devonshire clergyman, the Reverend John Russell. His ambition was to breed a strain of working Terrier to run with the hounds – dogs that would have the will and ability to tackle any adversary. He chose good working dogs as stock, mainly types of wire-haired Fox Terriers.

Although this popular little dog is not recognized by the English Kennel Club as a separate breed, a flourishing Jack Russell Terrier Club has been formed and a Breed Standard drawn up; there is little doubt that in time it will gain recognition.

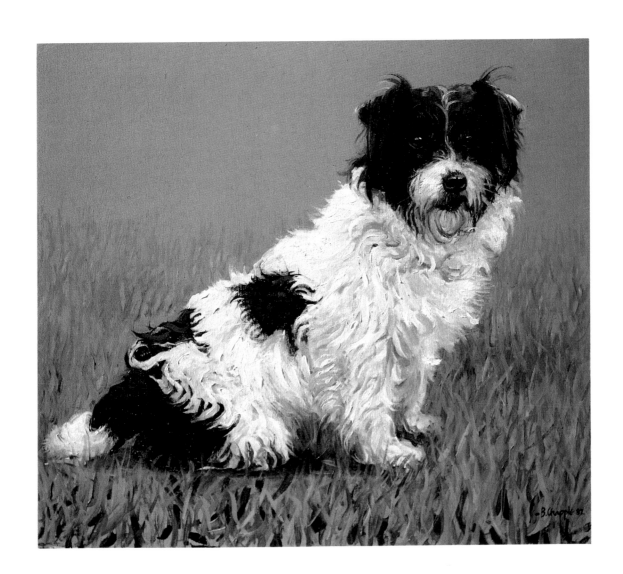

Cherry

Cherry, who was born on 15 January 1977, considers herself to be of the Papillon aristocracy, since she was sired by Champion Stouravon Cointreau and is a progeny of the famous Stouravon line. It is perhaps not surprising that this regal lady holds herself aloof, knowing that she is a worthy descendent of her Continental forebears.

She is discriminating with her affection, but is a very loving creature and always keeps herself immaculate in appearance.

Cherry posed proudly for her portrait, having settled like an exquisite butterfly upon this appropriately chosen cushion, which seemed to have been kept specially for the occasion.

PAPILLON Not surprisingly, this little Continental dog with fringed ears acquired its name from the French word for butterfly.

The Papillon, once admired and owned by Marie Antoinette and Madame de Pompadour, can be seen in the paintings of Rubens, Van Dyck, Fragonard and Watteau.

The breed has been known for centuries and was first popular in the Royal Courts of Spain. Later the fashion for these delightful dogs spread to Italy and France, where they were treasured companions to ladies of the Royal Household. Following the French Revolution and the fall of the monarchy, the dainty, elegant yet hardy Papillon made its home in exile.

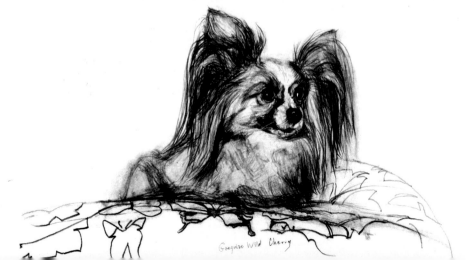

Gregrise Wild Cherry

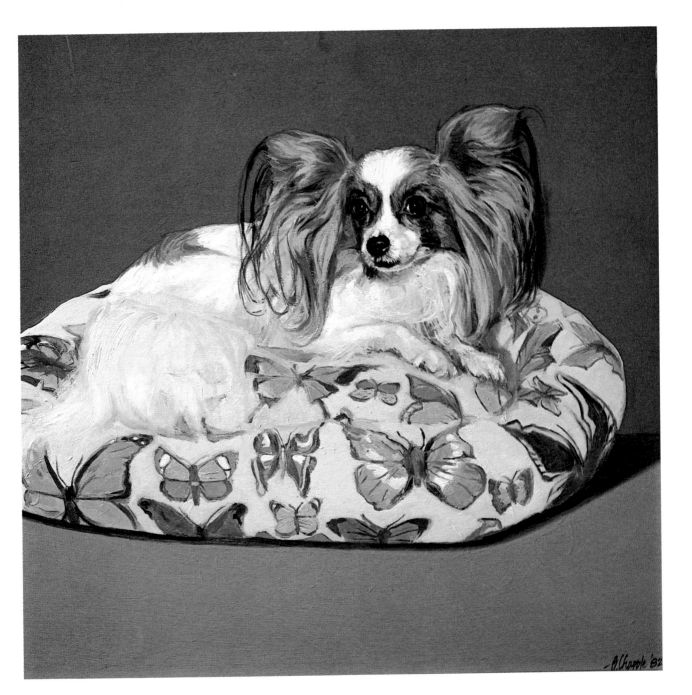

-A.Chapple '82

Tara

Three-year-old Tara, whose great-grandfather had the distinction of being judged Supreme Champion at Crufts in 1971, lives happily as a much-loved family pet in Cornwall. She is owned by young Steven and every day eagerly awaits his return home from school. There is also a small Dachshund in the household and, despite jealousy on both sides, Tara is always permitted to display superiority by rolling the little one over with her paw. For ever happy to be the centre of attention, Tara seemed to delight more than most in posing for this picture, displaying proudly her beautiful ears and fluffy tail.

GERMAN SHEPHERD The German Shepherd dog is a very old breed and has been used to guard and herd sheep for centuries. Commonly known in Britain – but not elsewhere – as the Alsatian, it possesses highly developed senses which make it an excellent dog for training in a variety of fields.

The German Shepherd has varied in appearance through history. The beautiful dog we know today was created in the late part of the nineteenth and early twentieth centuries as a result of intensive and skilful German breeding. It is an active, alert, good-natured and highly intelligent dog.

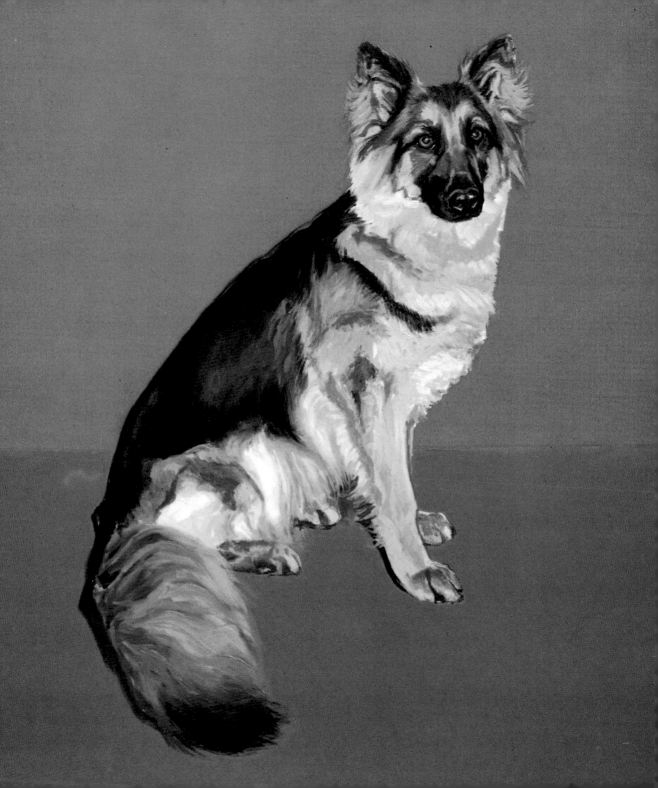

Flash

As a small puppy, Flash picked out his new owner by sitting firmly at his side while the rest of the litter edged uncertainly backwards and forwards. Flash had made up his mind; and from that moment until the day he died, he remained his owner's constant companion, only really happy when they were together.

He was a character dog, an ardent television viewer and always eager to learn new tricks. Flash responded extremely well to training and entered his first Obedience Show at the age of three, coming away with two rosettes. These were to be followed by many more, displayed in the background of his portrait.

Although not particularly good tempered with other dogs, he was marvellous in the company of puppies and would play for hours with them if given the chance. Flash was a good guard in the car, allowing no one near; but as a watchdog at home he was hopeless, greeting without a sound anybody that went to the house. It was over a year before he barked for the first time and then frightened himself, not quite understanding from where the noise was coming.

Flash died tragically at the age of six and a half whilst on a day out in Plymouth. 'Even though I shall always have dogs,' his owner said, 'I do not think I will ever be privileged to be owned by another dog like Flash – he owned me, I didn't own him!'

BORDER COLLIE The Border Collie we know today is a modern strain of working sheepdog, the product of careful and selective breeding. It has inherited all the qualities and instincts of its ancestors, the early drovers' and shepherds' dogs of the border region between England and Scotland. Today, the Border Collie has found its way to every country where sheep are herded. In recent years the breed has become very popular and successful in Obedience Competitions. Border Collies are highly adaptable and with proper training can be relied upon to excel in almost anything.

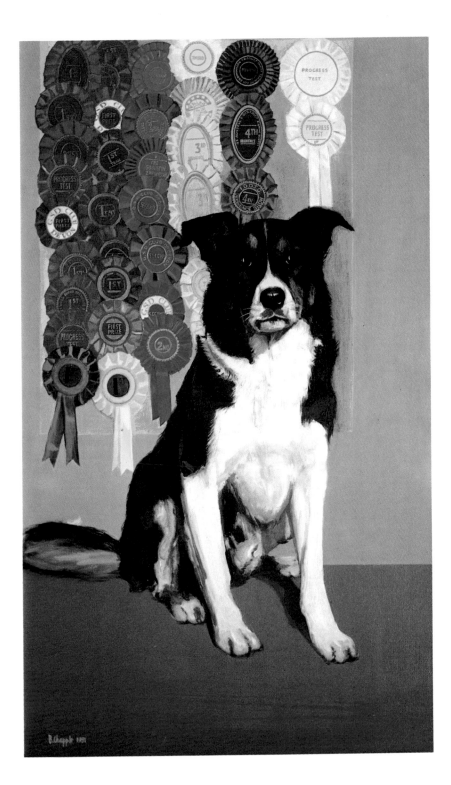

Jinx

Champion Reaching Pentewan, known as 'Jinx', is one of a long line of champions bred in Wadebridge, Cornwall. Besides being a champion herself, she is the mother of champions, one in particular being Champion Rych Pyscador, who was Pup of the Year in 1981 and Greyhound of the Year in 1982. She also has sons and daughters who are champions in Norway and Belgium. For the past two years, Jinx has lived in Sweden and has become an International Champion. She is now enjoying life at the country house of her Swedish owners, who have recently settled in the south of England.

GREYHOUND Dogs of the Greyhound-type can be traced back many years BC to the friezes and monuments of ancient Egypt and Babylon. Throughout the ages, these noble and graceful hounds have retained a greater purity of form than most other breeds, changing very little with the passage of time. Greyhounds have always been associated with the English monarchy and were provided for in the forest laws of King Canute, who forbade anyone under the rank of a gentleman to own one.

 The Greyhound has been developed on three different lines in recent years: the show dog, the coursing dog and the track greyhound. It has been a popular competitor since the early days of dog shows and is a magnificent dog in the show ring. The show dog differs from the working greyhound in that the emphasis is placed on show points, while a coursing or racing hound (such as Kerry) is naturally judged by performance.

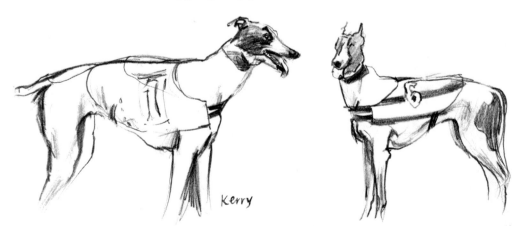

Kerry

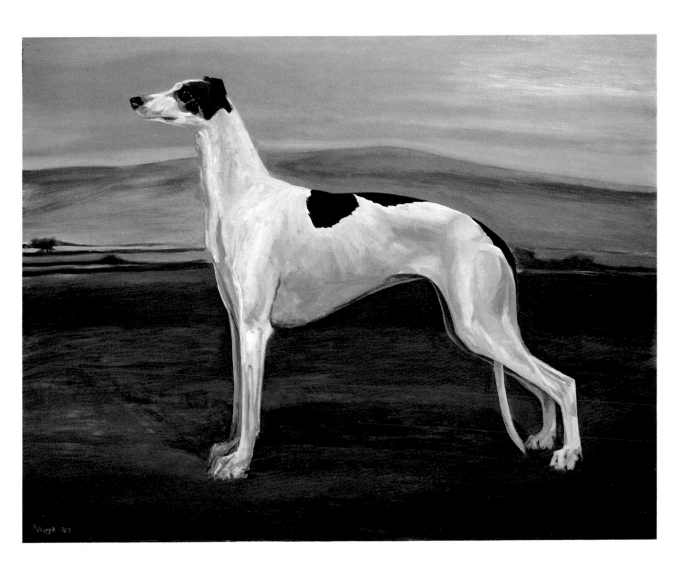

Benson was a retirement gift from the staff of Truro High School in Cornwall. He was named after the famous Archbishop of Canterbury, Edward White Benson, who founded the school in 1880 while he was Bishop of Truro.

The choice of puppy was left to the owner. She had the good fortune to obtain him from a young animal geneticist who had chosen the father of the puppies with great care. Ben is so good tempered that he is now helping to socialize a rather aggressive Terrier and takes not the slightest notice of the little dog's attacks.

Pleasantly relaxed yet watchful and hopeful, waiting for the book to be closed or the pen to be laid down – that's Benson in real life and in the painting.

WELSH SPRINGER SPANIEL The Welsh Springer is a spirited and active dog built for endurance and hard work, well suited to the rough mountainous country of its native Wales. It is a good hunter and springer of game and one of the best all-round gundogs, capable of retrieving from land and water. Slightly smaller, with finer bone and more silky coat than its cousin the English Springer, the breed is easily distinguished by its colour, which is always a dark, rich red and white. The Welsh Springer Spaniel responds keenly to training and makes a good show dog that is steady and fearless in the ring.

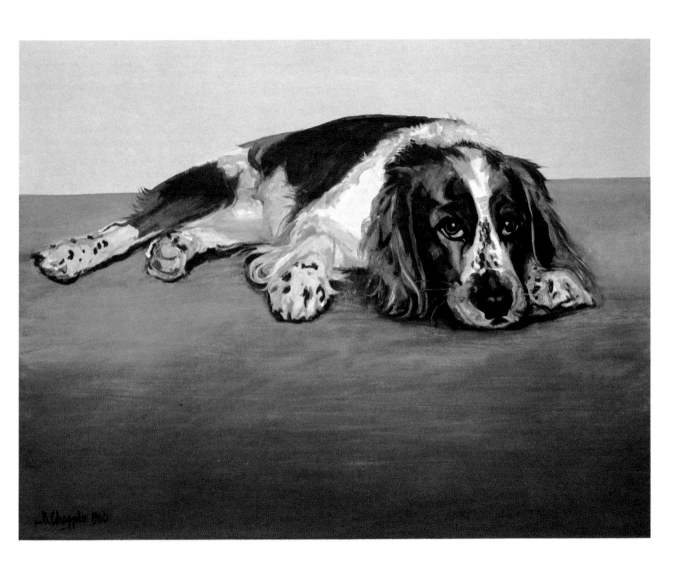

Acknowledgments

My grateful thanks to all who have kindly agreed to their dog portraits being reproduced in this book, and for supplying such interesting notes and stories.

A special thank you to my parents who have always given me support and encouragement in my work, and to my husband for his tolerance and patience in sharing a dog-filled life.

I would also like to thank my cousin Valerie for typing the script.

. . . And thank you dogs for being such perfect subjects.

Beryl Chapple

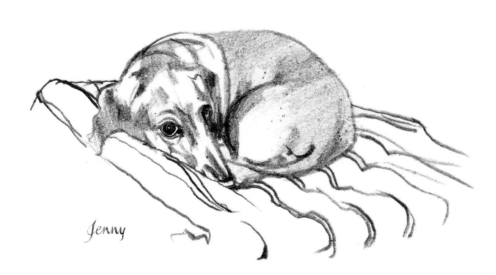

Jenny